PORN ●FOR
new m♥ms

From the Cambridge Women's Pornography Cooperative

Photographs by Susan Anderson

CHRONICLE BOOKS

SAN FRANCISCO

PORN ● FOR
new ♥ moms

A PORN FOR book. PORN FOR is a trademark of Urgent Haircut Productions.
Library of Congress Cataloging-in-publication Data:
Porn For New Moms / From The Cambridge Women's Pornography Cooperative ; Photographs By Susan Anderson.
P. Cm.
Includes Index.
ISBN-13: 978-0-8118-6216-5
1. Mothers--humor. 2. Motherhood--humor. I. Anderson, Susan, 1963-
Ii. Cambridge Women's Pornography Cooperative.
Pn6231.m68p67 2008
817'.608--dc22

Printed in China
Designed by Stella Lai

Producer: Michael Rochetti / Starpoint Studios
Photographer's Assistants: Loren Earl Criuckshanks & Dyami Serna
Post Production: Rob Milkoski
Retoucher: Matthew Triska
Stylist: Micah Bishop, Artist Untied
Assistant Stylists: Ebony Haight & Ellisa Blackwell
Models: Westley Boggess, Joshua Holland, Jason Holmes, Michael Johnson, Jeff Mustille, & Dimas Velasquez, all from Look Model Agency
Baby models: Ava Maurizia Burnett-Cavoto, Sophia Elisabetta Burnett-Cavoto, Caskey Gillingham, and Ava Moyrong

The photographer would like to thank:
Deborah Ayerst Artists Agent for getting me my start in porn (for women); Starpoint Studio & Michael Rochetti for making the production seamless; Loren & Dyami for their hard work & good humor; Butterscotch Bogaards in Mill Valley & Jodi Warshaw in San Francisco for providing the beautiful locations; Micah Bishop for her flawless taste; Al Lacayo at Look Models for handsome guys that work well with babies; our four adorable infants and their parents for their participation; & Jodi Warshaw, Kate Prouty, and Aya Akazawa at Chronicle Books for their creative inspiration & collaborative spirit.

10 9 8 7 6 5

Chronicle Books LLC
680 Second Street
San Francisco, California 94107

www.chroniclebooks.com

What really turns new mothers on?

We at the Cambridge Women's Pornography Cooperative (CWPC) have devoted ourselves to answering this burning question.

It wasn't easy. We spent months in the lab testing all manner of titillation. We brought in all sorts of men—blondes, redheads, tall-dark-and-handsomes. We tried them shaven. We tried them scruffy. We tried them all clad, half-clad, and not clad. The response? Lukewarm.

Then a strange thing happened. A CWPC member's husband happened to stop by the lab with the couple's newborn. At that moment, we had this new mother hooked up to the sensors while viewing a shirtless fireman. When she turned to see her husband nestling their baby in his arms, it happened. Her pulse raced, her pupils dilated, and respiration quickened. Eureka!

Using this data, we brought in other new mothers from the control group and had them view dads with babies. The readings spiked. And when we had the dads perform simple household chores, well, the pornometer went off the charts.

What follows, offered with explicit photographic evidence, is the result of our study. Prepare to enter a world where men insist on changing diapers, where men couldn't imagine letting you lift a finger around the house after bearing the child, where men invite their buddies over to play with the baby, and where sleep comes in uninterrupted eight-hour intervals. Now that's hot!

—Cambridge Women's Pornography Cooperative

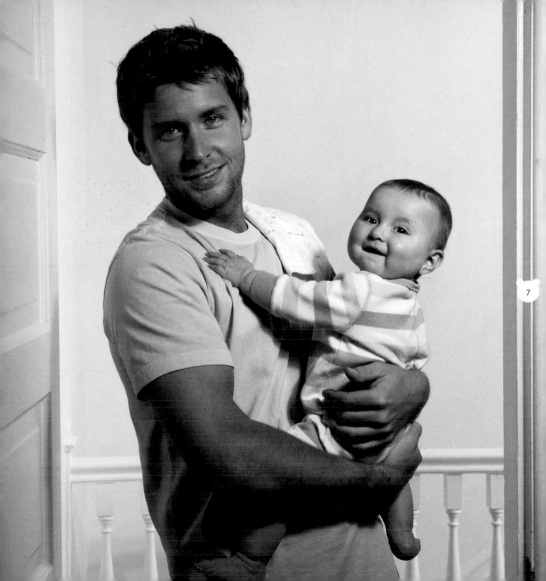

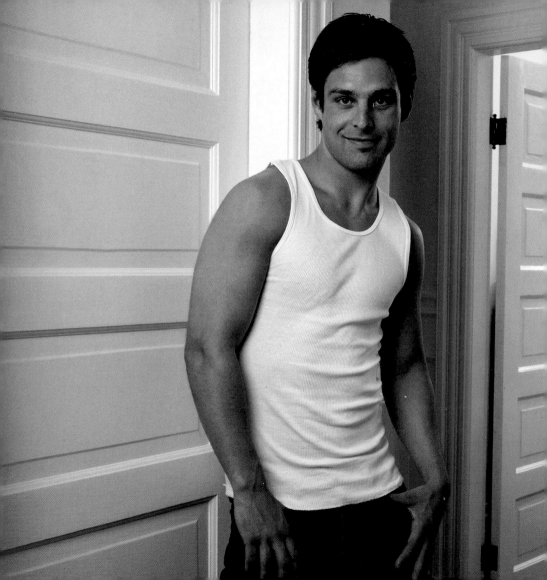

Damn!

You look **hot** in
those **sweatpants!**

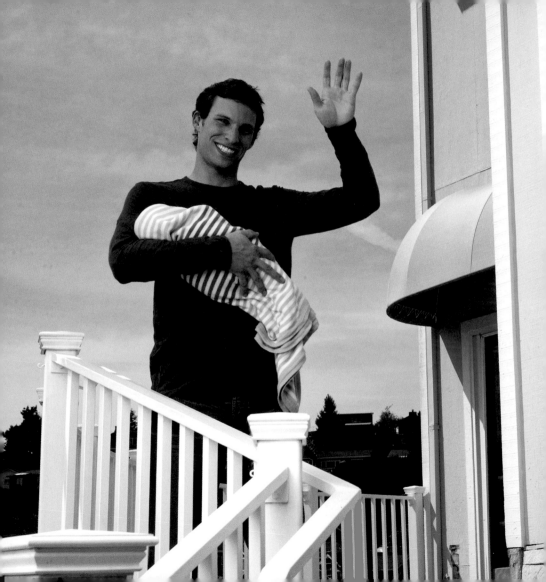

Don't worry, honey. Your mother and I will take wonderful care of the baby while **you and your girlfriends** are at the **spa**.

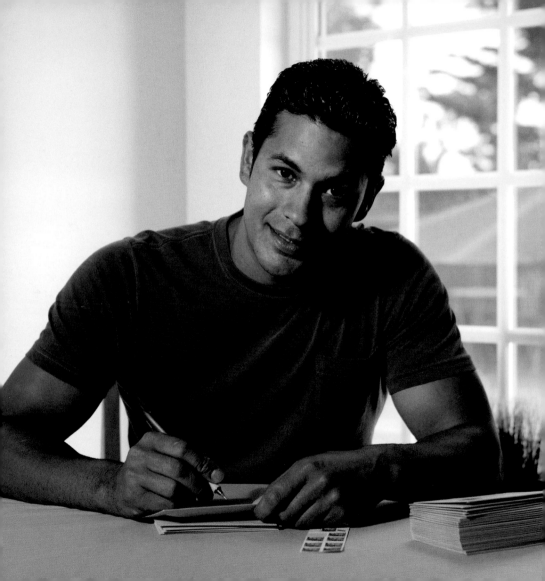

I'll be right there, hon. I'm just finishing the last of the **baby shower** thank-you cards.

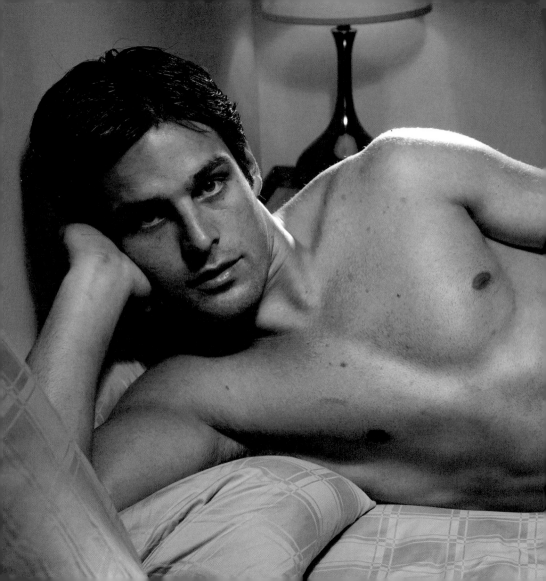

Let's **not have sex** tonight. Let me just **rub your feet** while you tell me about the **baby's day.**

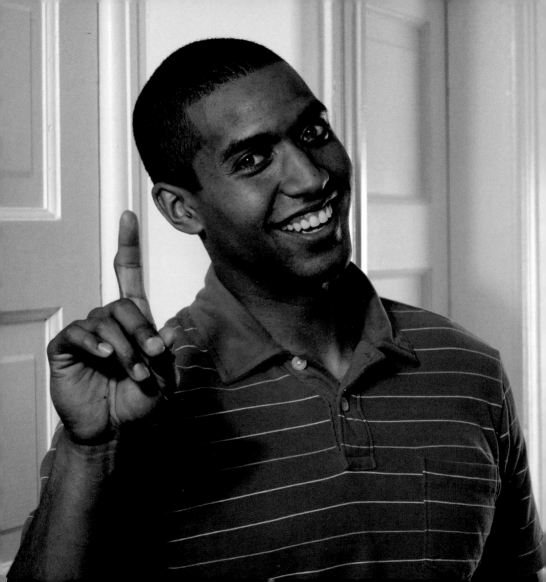

Oh, good,
she **spit up**. I've got a new
organic stain remover
I've been dying to try.

Let me get rid of this junk, so we'll have room in here for the **jogging stroller**.

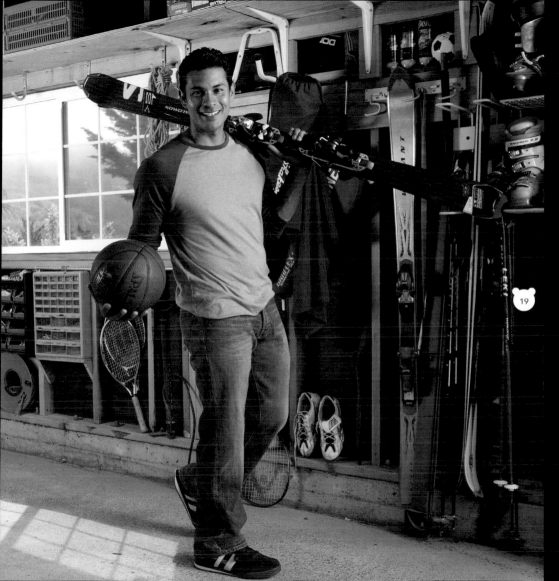

Look! She **loves** the sound of the vacuum cleaner. And you should see her light up when **I damp mop!**

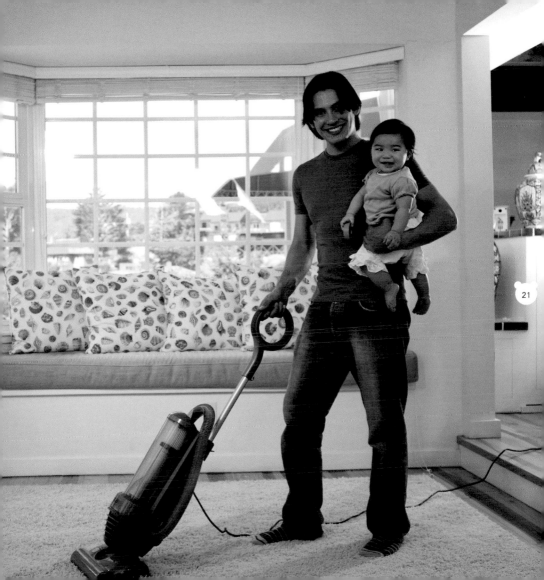

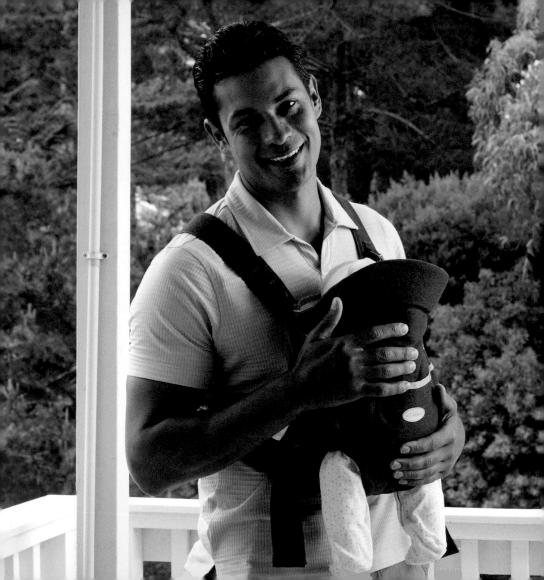

I'm taking her to the **women's soccer game**, and then we'll stop at the **supermarket** on the way home.

No, you **relax** for a while.
I've figured out
how to **fold** everything
one-handed.

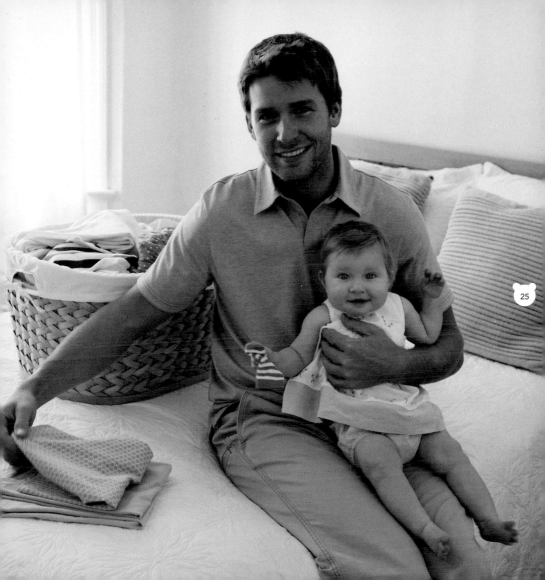

Well, **Inga**,
the **19-year-old Swedish**
au pair, is sweet and all, but
I'd prefer an **older nanny**
with more experience.

… and in just **eight** more hours, we can **wake up** mommy!

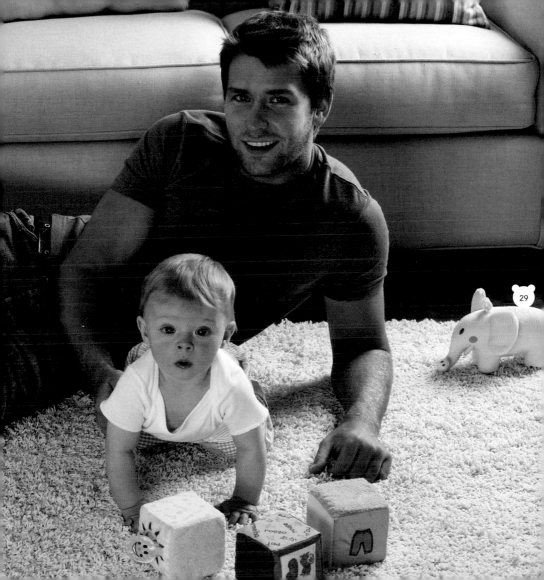

Today **Little Pea**, tomorrow I'm going to read her **The Time Traveler's Wife.**

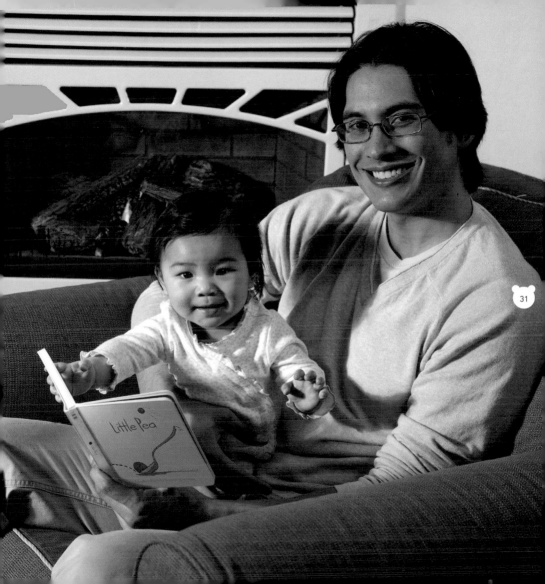

Ah, the
sports pages can wait.
I'd rather get a jump
on these **preschool**
applications.

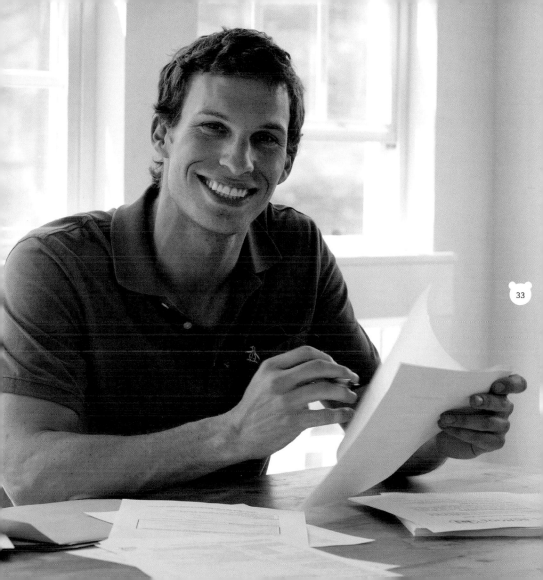

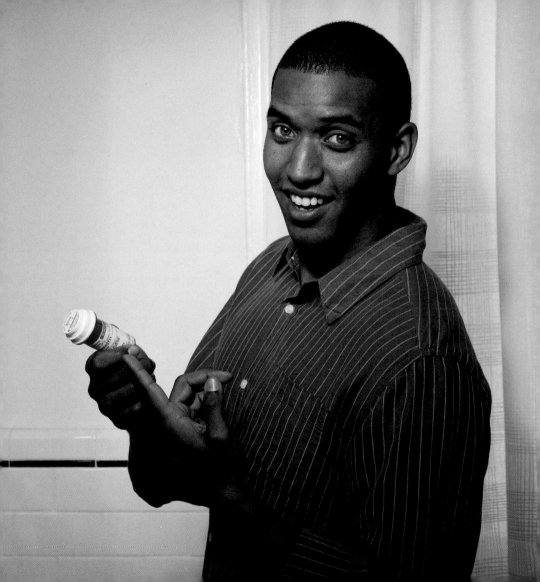

Look what I got for you. It's a combination sleep-aid, **mood-enhancer**, breast-pain reliever, and **headache preventative!**

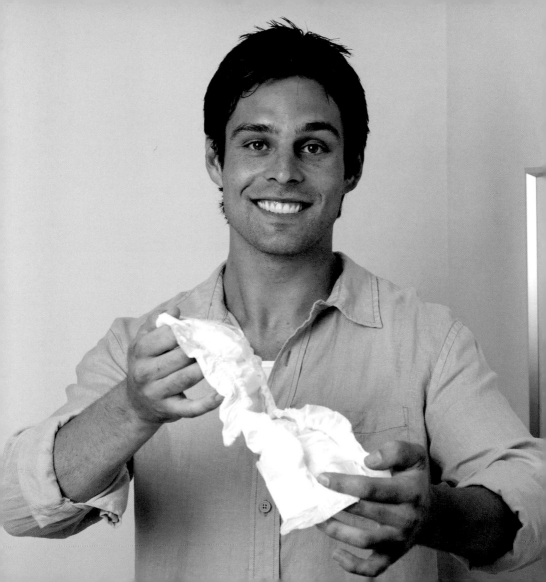

Honey, I found this
new diaper that's **inexpensive**,
biodegradable, **doesn't** ever
leak, gets **delivered** to the house,
and practically **changes itself!**

So, **tell me** again, what was the **consistency** of the **poop**?

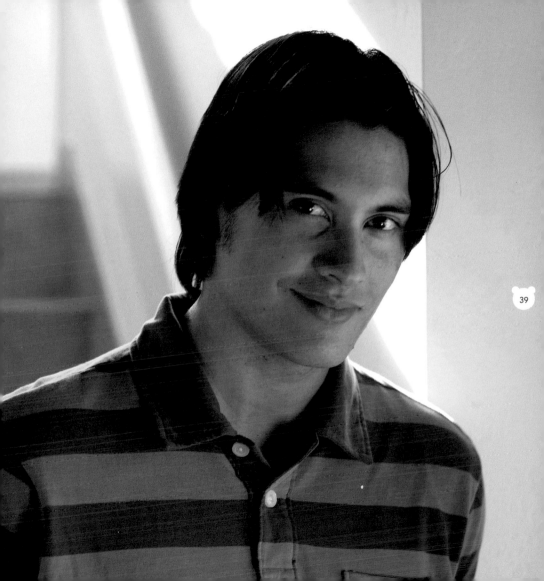

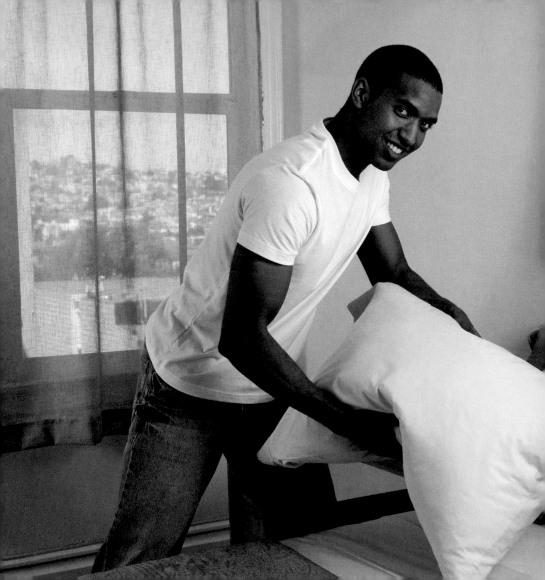

I changed the sheets so we can all snuggle up together in a **nice, clean bed.**

Now, which of you ordered the **wasabi chicken with fresh spinach,** and which one ordered **mashed carrots and peas?**

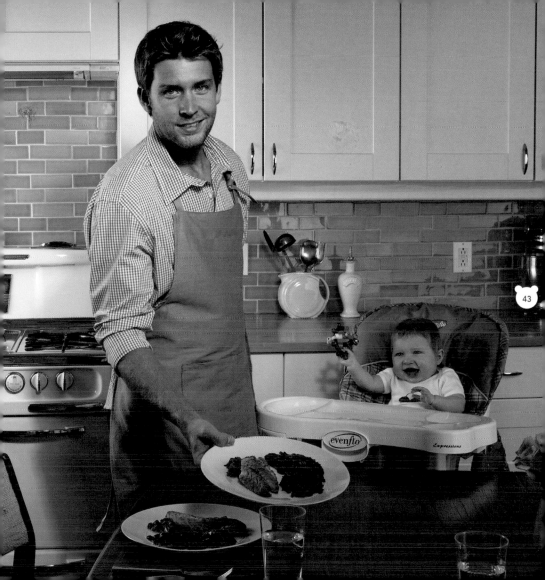

Honey, they've **cured colic**!

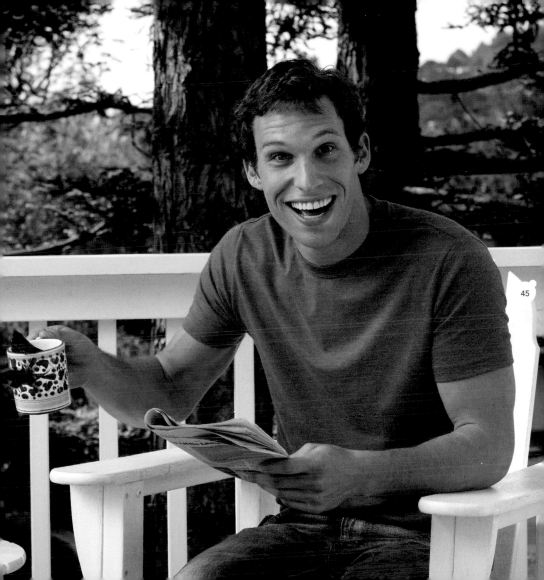

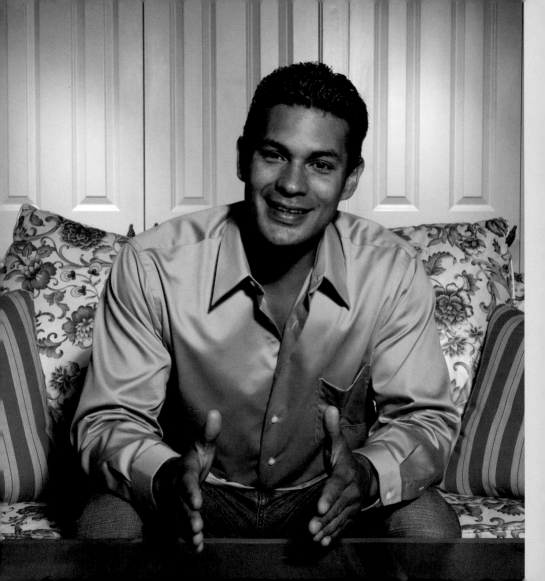

Look, if you don't want to go **back to work**, let's just tap into my **family's trust fund** to pay for daycare. Didn't I ever tell you about that?

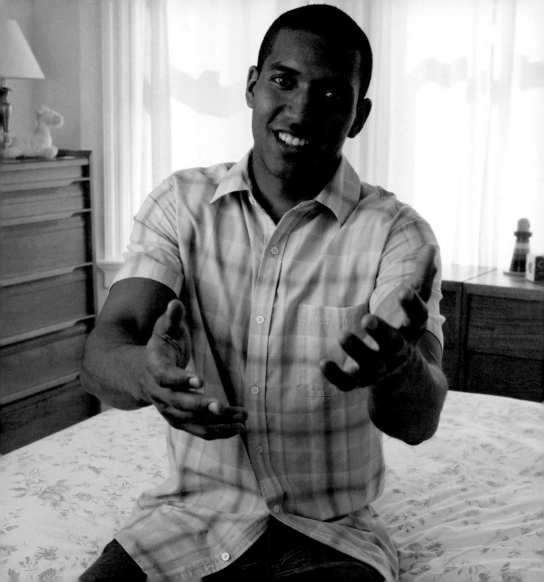

Who says there's no such thing
as a **paternal instinct?!**
Hand over that **beautiful baby!**

Every time I see a **cute**, **young** co-ed these days, all I can think is, **"potential babysitter."**

I figure if I **drop the sports channels**, we'll **max out** the **college fund** in no time!

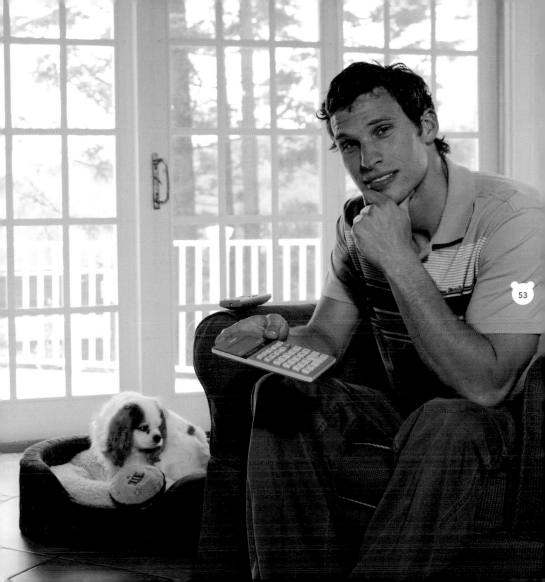

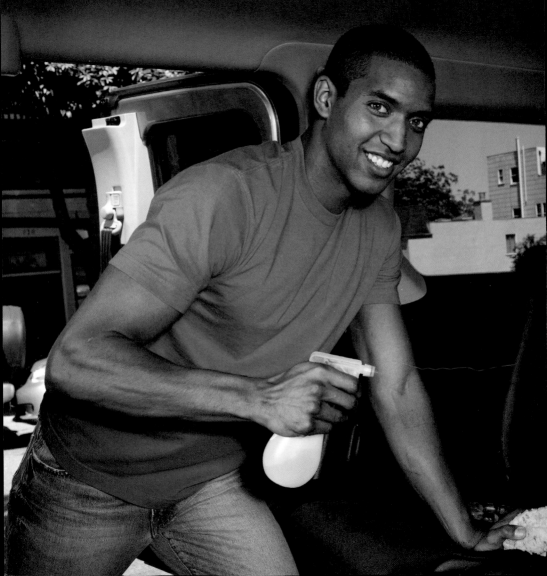

Dried milk and **spit up**,
prepare to
meet your match!

OK, **you can hold him** for **a minute**, but I want him right back.

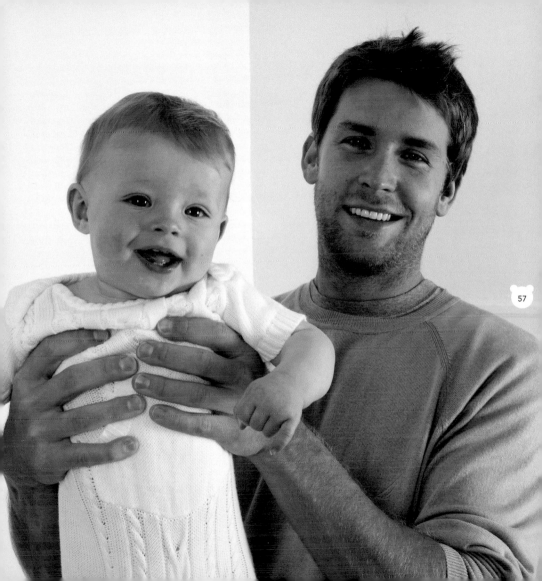

I found someone to take my tee time again this **weekend** so I can **spend more time** with **you** and the **baby**.

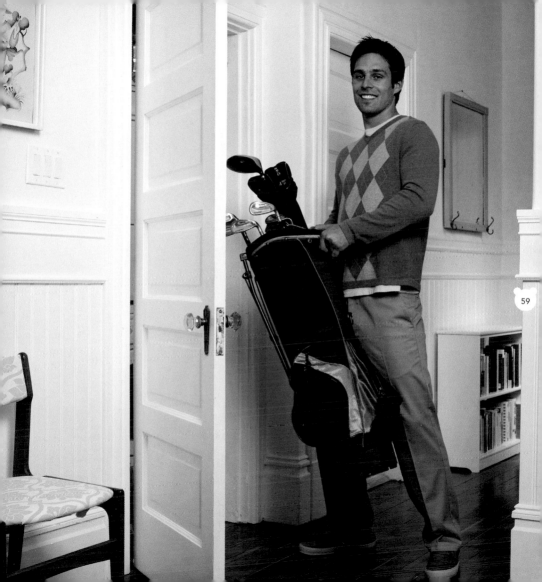

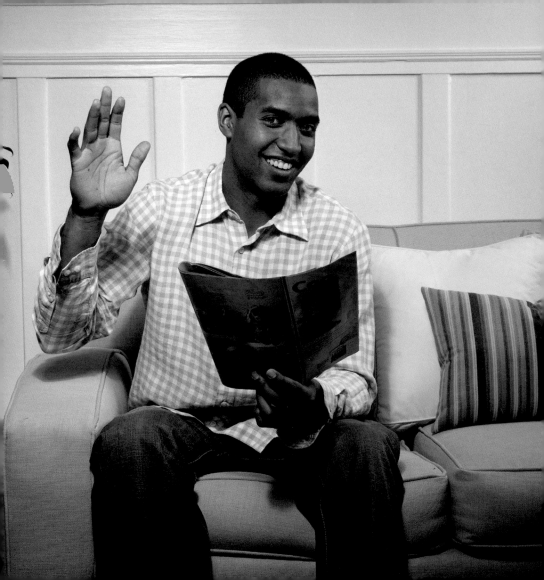

Sure, **your girlfriends** can drop **their babies** off here while **you girls** go to **the bar**. The more the **merrier**.

And this is the way **mommy likes** her **duck l'orange** with **fresh** snow peas …

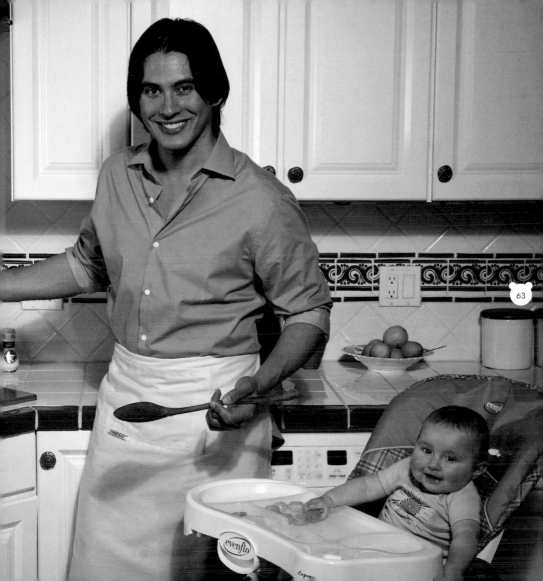

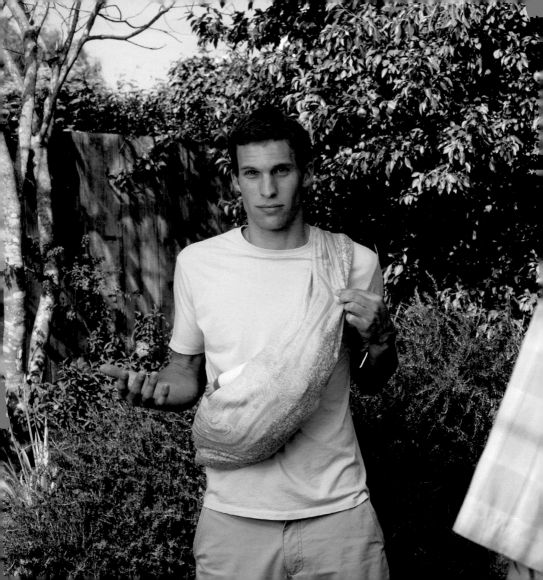

Yeah, it's a **Maya Wrap**.
You guys have a
problem with that??

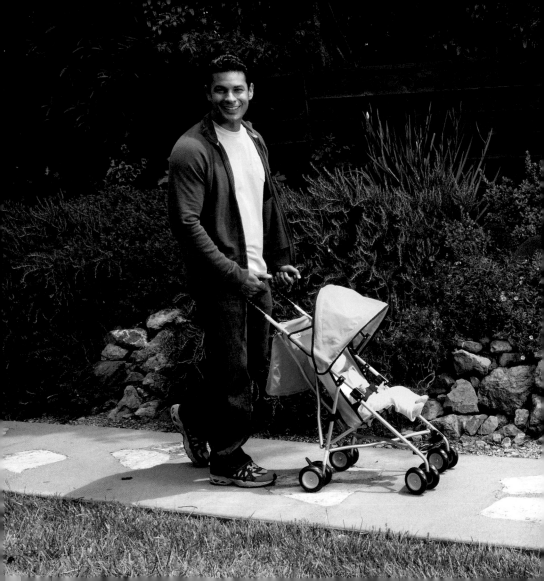

You want us back home already? C'mon, I've only had him for a **few hours**.

You say **your breasts** have **gotten smaller** since the birth? **I hadn't noticed**. They look **amazing**!

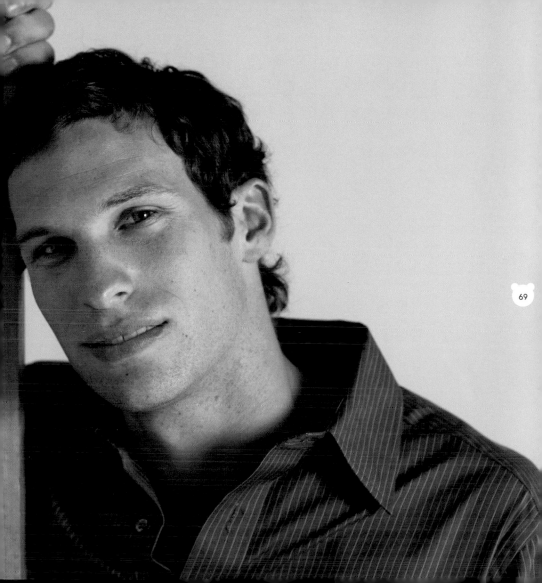

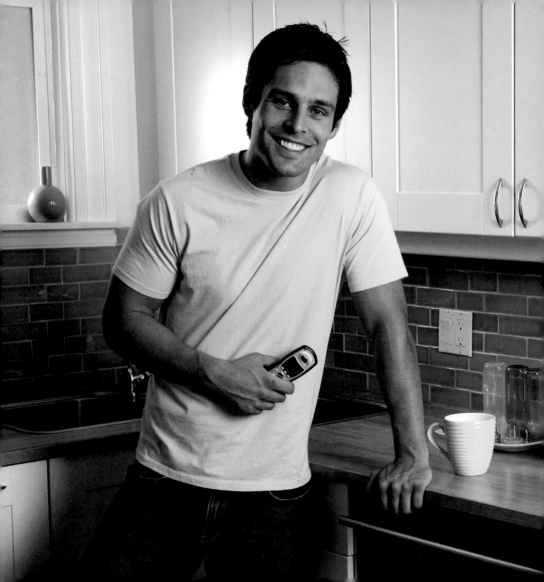

Hey, **the guys** are coming over. They **want to help** me take the **baby to the park!**

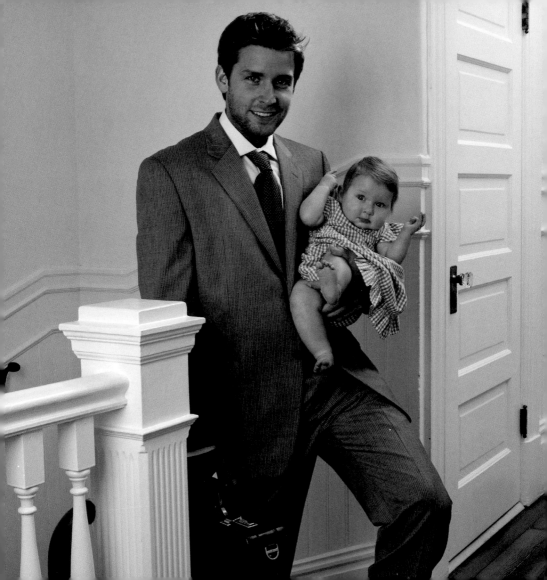

I told my boss I have to **leave** at **3:00** every afternoon so I can **come home** and **give you a break**.

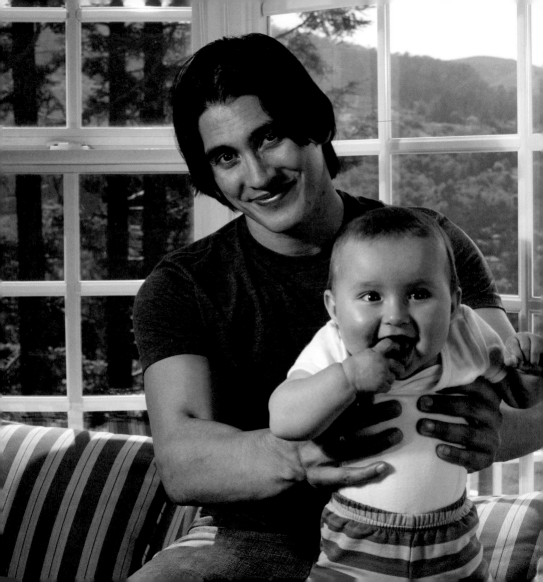

Ooh,
volcanic eruption with
major blowout. That's **so
cute**. I'll **change her**.

I traded in **my sports car** for a **Volvo wagon**. It's got **18 airbags, 17 crumple zones**, and **built-in baby seats!**

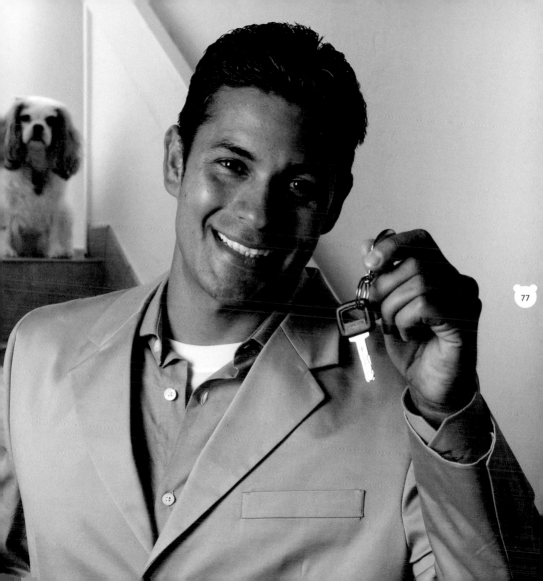

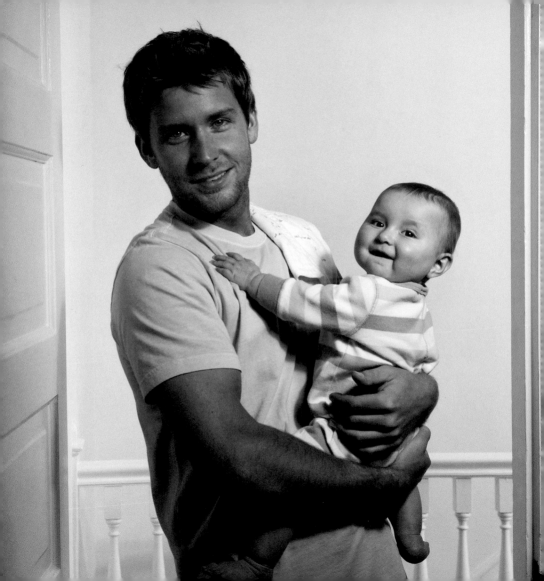

Honey, **you are SO right**. The baby always does **spit up** when **I toss her in the air** right **after she eats**! Now remind me, what were those other things **you told me not to do?**

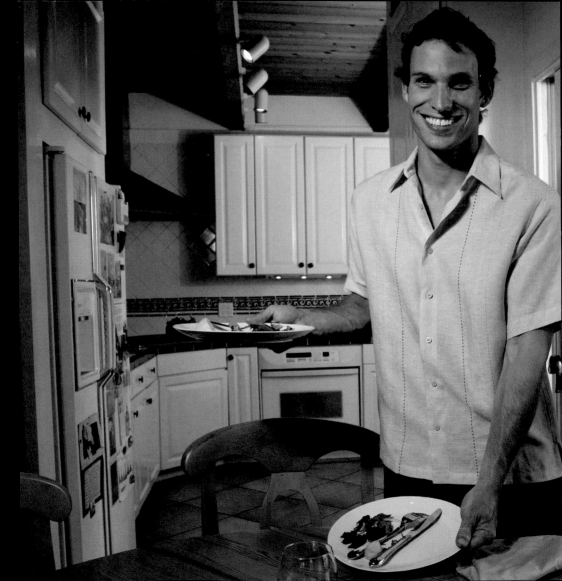

No, no! Sit down!
I'll do the dishes.
After nine and a half months
of pregnancy, 26 hours of
labor, and 18 stitches,
**you don't have to do a
damn thing around here!**

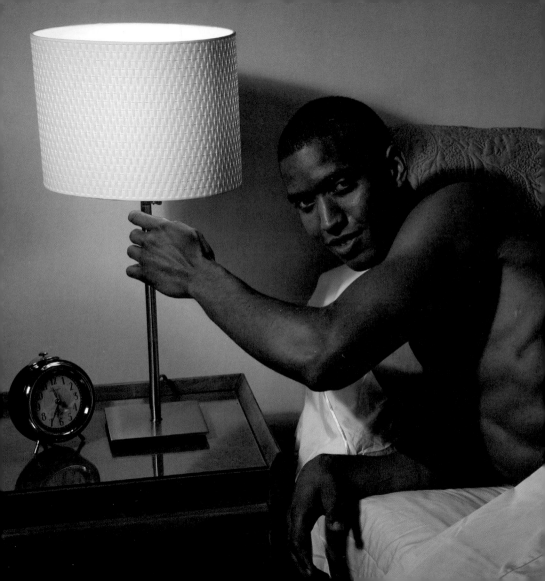

Now, remember,
it's my turn to do the
midnight feeding, so
don't get up!

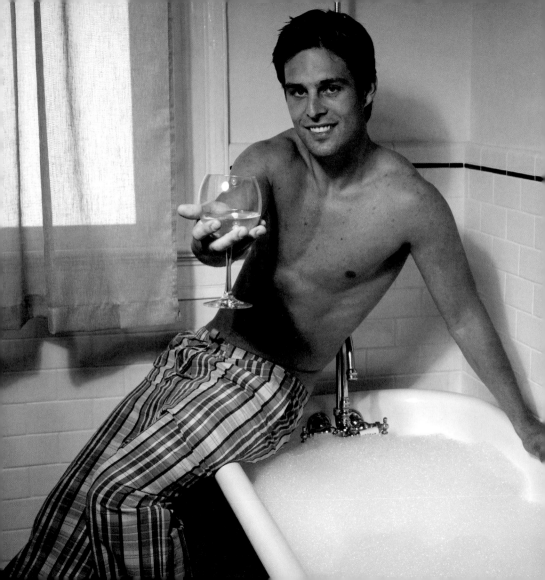

I poured your bath, and here's a glass of **Chardonnay.** And **don't worry**… even if it gets into the breast milk, it'll just help him **fall asleep faster.**

If **I promise** to do all the laundry and diaper changing for the **next few years**, can we have another one?

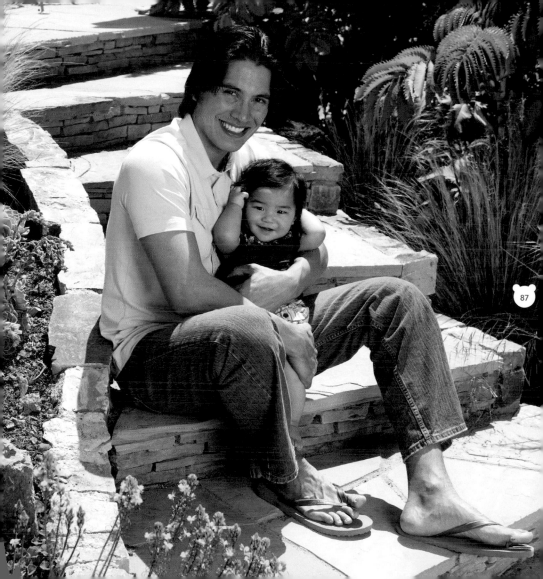

★ PORNOMETER ★

How much Are **You** getting?

When the baby cries in the middle of the night, does he:

 A Quietly urge you to get some more sleep while he gets up and bottle-feeds the baby?

 B Gently wake you and say he's sorry, but the baby needs you?

 C Break out in a fake snore while forcefully pushing you out of bed with both feet?

When he comes home from work, does he:

 A Kiss you, take the baby, and suggest you take some time for yourself?

 B Ask how your day was and willingly help when asked?

 C Ask if dinner's ready yet, because he has to be at his poker game by 7:00?

When the baby projectile vomits across the living room, does he:

- **A** Drop everything and run for a towel and damp sponge?
- **B** Stand there slack jawed, not sure what to do?
- **C** Ask you if you can make it happen again, so he can videotape it for his buddies?

When you remark on how hard it is to lose those extra child-bearing pounds, does he:

- **A** Tell you he loves you more than ever, and that a few pounds could never change that?
- **B** Suggest that he could lose a few pounds himself, and offer to bring some healthier food into the house?
- **C** Start making obnoxious beeping sounds whenever you back up?

When you go to bed at night, does he:

- **A** Tell you what a great mother you are, and what a wonderful kid you two have?
- **B** Tell you he's exhausted, but recognize that you must be exhausted, too?
- **C** Complain that you won't let him play with your breasts, even though you give the damned baby almost unlimited access?

When the weekend approaches, does he:

> **A** Suggest fun things you guys can do with the baby, and offer to give you some extra time to sleep?
> **B** Offer to take the morning shift on Saturday so you can sleep in?
> **C** Ask you not to leave the stroller in front of his golf clubs, because he'll need them both Saturday and Sunday?

When the baby spits up on your shirt, does he:

> **A** Bring you a fresh shirt, and take the baby and clean her up?
> **B** Toss you a towel so you can wipe things up?
> **C** Look at you and say, "Ewww, somebody's not getting a hug tonight!"?

When your mother comes to visit, does he:

> **A** Make an effort to make sure Grandma gets to know her grandchild?
> **B** Suggest that perhaps you two could go out together on a date while Grandma watches the baby?
> **C** Make plans to go to Stripper Weekend in Las Vegas since you "obviously won't be needing him"?

When you nap and ask him to watch the baby, does he:

 A Give the kid a bath, do some laundry, and make some dinner plans?
 B Agree, but then let the baby cry so much that you eventually give up on your nap and get up anyway?
 C Head to the nearest park and tell single women a sob story about what it's like for a young widower to raise a child all by himself?

When you tell him you worry about the baby while she's sleeping in her crib, does he:

 A Do a bunch of research on the Internet, and show you that you're doing everything possible to take good care of your baby?
 B Give you a hug, and tell you not to worry, everything will be fine?
 C Admit that maybe it was a bad idea for him to take the baby video monitor camera away from the crib and set it up in your visiting sister's room?

Porn Points
A = 3 Points
B = 1 Point
C = -3 Points

15 – 30 Points: Hello, daddy!
01 – 15 Points: Have your guy read this book. Twice.
-30 – 0 Points: Hopeless. Seek an immediate upgrade.

Afterword

Want to do your part to improve the world? Keep this book in plain sight on your coffee table so that visiting new mothers, or enlightened new fathers, can be inspired, too. Future generations will thank you!

Also check out the best-selling book, *Porn for Women*, which includes fantasies for women of every life stage. Is there ever a time at which you don't appreciate a guy saying "I just want to be sure we always have chocolate in the house."

Have some fantasies you want to share with us? Send them to us via our Web site, **www.chroniclebooks.com/porn.** Maybe your idea will be included in a future book, and you'll be an honorary member of the Cambridge Women's Pornography Cooperative!

What makes you hot?